1 0 0
LEADERSHIP

ARCTURUS

With special thanks to Tim Glynne-Jones

ARCTURUS

This edition published in 2015 by Arcturus Publishing Limited
26/27 Bickels Yard, 151–153 Bermondsey Street,
London SE1 3HA

ISBN: 978-1-78212-437-5
AD003730UK

Printed in China

Contents

Introduction

Samuel Johnson once observed, 'No two people can be together for even a half an hour without one acquiring an evident superiority over the other', and it certainly does seem that the majority of us are apt to seek leadership in

whatever endeavours we pursue. But as we all know, some leaders are better than others. This book is a valuable collection of the wisdom and experience of people who have succeeded and failed in leadership, offering you all the clues you need to make a success of any opportunity to take charge that comes your way.

What is Leadership?

How do we define leadership?
What do we expect from our leaders
and how do they benefit our world?

Leadership involves finding a parade and getting in front of it.

John Naisbitt

A ruler with discernment and knowledge maintains order.

In this world a man must either be an anvil or hammer.

Henry Wadsworth Longfellow

Leadership is the art of getting someone else to do something you want done because he wants to do it.

Dwight D. Eisenhower

Effective leadership is putting first things first.

Stephen Covey

Government is ourselves.

Franklin D. Roosevelt

Leadership is the fruit of labour and thought.

Leadership is the capacity to transform vision into reality.

Warren Bennis

A sufficient measure of civilization is the influence of good women.

Ralph Waldo Emerson

A leader is best when people barely know he exists. When his work is done, his aim fulfilled, they will say: we did it ourselves.

Lao Tzu

A teacher affects eternity; he can never tell where his influence stops.

Henry Adams

Leadership is a potent combination of strategy and character. But if you must be without one, be without the strategy.

General Schwarzkopf

Effort and courage is not enough without purpose and direction.

I light my candle from their torches.

Robert Burton

It is the stars,
the stars above
us, govern our
conditions.

William Shakespeare

Great leaders build you up.

What is government itself but the greatest of all reflections on human nature?

James Madison

When you come to look back on all that you have done in your life, you will get more satisfaction from the pleasure you have brought into other people's lives than you will from the times that you outdid and defeated them.

Rabbi Harold Kushner

Leadership is the capacity and the will to rally men and women to a common purpose and the character that inspires confidence.

General Montgomery

A negative thinker makes everything worse, heavier and harder. A positive thinker makes everything better, lighter and easier.

A director is a choreographer, both politically and creatively.

William Shatner

Heroes inspire us to be better than we are.

What gets measured gets managed.

Peter Drucker

Inventories can be managed but people must be led.

Ross Perot

To govern is to choose.

Nigel Lawson

To walk safely through the maze of human life, one needs the light of wisdom and the guidance of virtue.

Buddha

America is a land where men govern, but women rule.

John Mason Brown

Authority doesn't work without prestige, or prestige without distance.

Charles de Gaulle

I am not afraid of an army of lions led by a sheep, I am afraid of an army of sheep led by a lion.

Alexander the Great

Coaching is taking a player
where he can't take himself.
Bill McCartney

**Leadership is the ability to
hide your panic from others.**

To govern is always to choose among disadvantages.

Charles de Gaulle

Leadership is being able to take it as well as dish it out.

Larry Bird

Leadership is influence.

John C. Maxwell

No one saves us
but ourselves. *Buddha*

Leadership has a harder job to do than
choose sides. To bring sides together.

Jesse Jackson

**Do what is right when
no one is watching.**

Make a difference.

A return to first principles in a
republic is sometimes caused by the
simple virtues of one man. His good
example has such an influence that
the good men strive to imitate him,
and the wicked are ashamed to lead
a life so contrary to his example.

Niccolò Machiavelli

Because power corrupts, society's demands for moral authority and character increase as the importance of the position increases.

John Adams

Either you think, or else others have to think for you and take power from you.

F. Scott Fitzgerald

A leadership is someone who brings people together.

George W. Bush

Power has only one duty: to secure the social welfare of the People.

Benjamin Disraeli

Real influence is measured by your treatment of yourself.

Amos Bronson Alcott

An oppressive government is more to be feared than a tiger.

Confucius

We pay a person the compliment of acknowledging his superiority whenever we lie to him.

Samuel Butler

When the sun rises, I go to work. When the sun goes down, I take my rest. I dig the well from which I drink. I farm the soil that yields my food. I share creation. Kings can do no more.

Chinese proverb

Divide and rule, the politician cries.
Unite and lead is the watchword of the wise.

Johann Wolfgang von Goethe

Government is not reason; it is not eloquent; it is force. Like fire, it is a dangerous servant and a fearful master.

George Washington

It is thought and feeling which guides the universe, not deeds.

Edgar Cayce

A man sooner or later discovers that he is the master-gardener of his soul.

James Allen

Men are governed only by serving them.

Victor Cousin

Power without a nation's confidence is nothing.

Catherine the Great, Empress of Russia

Leadership is diving for a loose ball.

Larry Bird

Selecting the right person for the right job is the largest part.

Phil Crosby

He that teaches us anything which we knew not before is undoubtedly to be reverenced as a master.

Samuel Johnson

If we have only one that can govern, and we choose him . . . does that mean we're not democratic?

Ahmed Ali

**Education should teach us how to think,
not what to think.**

Reputation is favourable notoriety
as distinguished from fame, which
is permanent approval of great
deeds and noble thoughts by the
best intelligence of mankind.

George William Curtis

Why in times of need do we call on that one person? Why do we confide in that one person. Why do we feel safe with that one person? Why would we follow that one person anywhere? Because that person is a leader.

Ben Greenhalgh

Good leadership consists of showing average people how to do the work of superior people.

John D. Rockefeller

It is the spirit of men who follow and of the man who leads that gains the victory.

General Patton

Effective leadership is not about making speeches or being liked; leadership is defined by results not attributes.

Peter Drucker

Leadership at one time meant muscles; but today it means getting along with people.

Mahatma Gandhi

**In a country well governed, poverty is something to be ashamed of.
In a country badly governed, wealth is something to be ashamed of.**

Confucius

Let the people think they govern and they will be governed.

William Penn

Leadership is related to change. As the pace of change accelerates, there is naturally a greater need for effective leadership.

John Kotter

Management is about arranging and telling. Leadership is about nurturing and enhancing.

Tom Peters

Lead and inspire. Don't try to manage and manipulate people.

Ross Perot

The true aim of everyone who aspires to be a teacher should be, not to impart his own opinions, but to kindle minds.

F.W. Robertson

To follow by faith alone is to follow blindly.

Benjamin Franklin

The herd seek out the great, not for their sake but for their influence; and the great welcome them out of vanity or need.

Napoleon Bonaparte

The influence you exert is through your own life.

Eleanor Roosevelt

Without subjects a prince is ruined.

It is not difficult to govern. All one has to do is not to offend the noble families.

Mencius

Leadership cannot just go along to get along. It must meet the moral challenge of the day.

Jesse Jackson

One of the tests of leadership is to recognize a problem before it becomes an emergency.

Arnold Glasow

The right doesn't need any ideas to govern, the left can't govern without ideas.

José Saramago

You campaign in poetry. You govern in prose.

Mario Cuomo

Leadership is solving problems.

General Colin Powell

The team should have implicit confidence in the captain's decisions.

Lord Mountbatten

Teaching kids to count is fine, but teaching them what counts is better.

You manage things; you lead people. We went overboard on management and forgot about leadership.

Rear Admiral Grace Hopper

Every government has as much of a duty to avoid war as a ship's captain has to avoid a shipwreck.

Guy de Maupassant

No power in society, no hardship in your condition can depress you, keep you down, in knowledge, power, virtue, influence, but by your own consent.

William Ellery Channing

One of the advantages of being a captain is being able to ask for advice without necessarily having to take it.

William Shatner

People need somebody to watch over them.

Arnold Schwarzenegger

The willingness to confront unequivocally the major anxiety of their people in their time. This, and not much else, is the essence of leadership.

John Kenneth Galbraith

Leadership is the key to 99 per cent of all successful efforts.

Erskine Bowles

Men are swayed more by fear than by reverence.

Aristotle

The only books that influence us are those for which we are ready.

E. M. Forster

The important thing is not so much that every child should be taught, as that every child should be given the wish to learn.

John Lubbock

The key to good leadership is setting the right standards.

Knowledge will forever govern ignorance; and a people who mean to be their own governors must arm themselves with the power which knowledge gives.

James Madison

If you left here tomorrow, would they still remember you?

The key to successful leadership today is influence, not authority.

Ken Blanchard

When a country is rebellious, it has many rulers.

Management is efficiency in climbing the ladder of success; leadership determines whether the ladder is leaning against the right wall.

Stephen Covey

No two people can be together for even a half an hour without one acquiring an evident superiority over the other.

Samuel Johnson

It would be difficult to exaggerate the degree to which we are influenced by those we influence.

Eric Hoffer

Leadership is lifting a person's vision to high sights, the raising of a person's performance to a higher standard, the building of a personality beyond its normal limitations.

Peter Drucker

The average teacher explains complexity;
the gifted teacher reveals simplicity.

The secret of my influence has always been that it remained secret.

Salvador Dalí

To do great things is difficult; but to command great things is more difficult.

Friedrich Nietzsche

The day soldiers stop bringing you their problems is the day you have stopped leading them.

General Colin Powell

The first responsibility of a leader is to define reality. The last is to say thank you. In between, the leader is a servant.

Max De Pree

Loyalty is a feature in a boy's character that inspires boundless hope.

Sir Robert Baden-Powell

Success is the ability to go from one failure to another with no loss of enthusiasm.

Sir Winston Churchill

The art of leadership is saying no. It's easy to say yes. *Tony Blair*

The woman who can't influence her husband to vote the way she wants ought to be ashamed of herself.

E.M. Forster

Mastering others is strength. Mastering yourself is true power.

Lao Tzu

Leadership is unlocking people's potential to become better.

Bill Bradley

The administration of justice is the firmest pillar of government.

George Washington

Thoughts rule the world.

Ralph Waldo Emerson

All the idols made by man, however terrifying they may be, are in point of fact subordinate to him, and that is why he will always have it in his power to destroy them.

Simone de Beauvoir

One father is enough to govern one hundred sons, but not a hundred sons one father.

George Herbert

Our business in life is not to get ahead of other people, but to get ahead of ourselves.

Power ought to serve as a check to power.

Montesquieu

The superior man understands what is right; the inferior man understands what will sell.

Confucius

To command is to serve.

André Malraux

We herd sheep, we drive cattle, we lead people.

General Patton

People respond better to reward than punishment.

Brian Eno

Power is action.

Honoré de Balzac

Power is of two kinds. One is obtained by the fear of punishment and the other by acts of love. Power based on love is a thousand times more effective and permanent than the one derived from fear of punishment.

Mahatma Gandhi

The man who builds a factory builds a temple, the man who works there worships there, and to each is due not scorn and blame, but reverence and praise.

Calvin Coolidge

The lips of a king speak as an oracle, and his mouth does not betray justice.

There is no necessity to separate the monarch from the mob; all authority is equally bad.

Oscar Wilde

Nearly all men can stand adversity, but if you want to test a man's character, give him power.

Abraham Lincoln

The Making of a Leader

What are the attributes required of a leader? Is it something you learn or is leadership a gift from birth?

A great soul will be strong to live,
as well as strong to think.

Ralph Waldo Emerson

Character is
power. *Booker T. Washington*

**Character is a diamond that
scratches every other stone.**

Cyrus A. Bartol

There are three essentials
to leadership: humility,
clarity and courage.

Fushan Yuan

**A good leader is a person who takes a little
more than his share of the blame and a
little less than his share of the credit.**

John C. Maxwell

Circumspection in calamity; mercy in greatness; good speeches in assemblies; fortitude in adversity: these are the self-attained perfections of great souls.

From the Hitopadesa

A sense of humour is part of the art of leadership, of getting along with people, of getting things done.

Dwight D. Eisenhower

Knowledge is power.

Francis Bacon

Knowledge will give you power, but character respect.

Bruce Lee

A cowardly leader is the most dangerous of men.

Stephen King

A leader is one who knows the way, goes the way, and shows the way.

John C. Maxwell

Cometh the hour, cometh the man. *Anon*

Character is the decisive factor in the life of individuals and of nations alike.

Theodore Roosevelt

Innovation distinguishes between a leader and a follower.

Steve Jobs

A great person attracts great people
and knows how to hold them together.

Johann Wolfgang von Goethe

A great teacher is a great artist.

John Steinbeck

**Everyone can be great,
because everyone can serve.**

Martin Luther King, Jr.

Don't push from behind, lead from the front.

He who pays the piper calls the tune.

Proverb

Leadership begins with being a follower.

Carolyn W. Ballard

Four things support the world: the learning of the wise, the justice of the great, the prayers of the good, and the valour of the brave.

Muhammad

Leaders aren't born, they are made. And they are made just like anything else, through hard work.

Vince Lombardi

He who has learned how to obey will know how to command.

Solon

Ill can he rule the great, that cannot reach the small.

Edmund Spenser

A servant serves, a fighter fights, a worker works, a dreamer dreams, a leader leads and does all these.

Being powerful is like being a lady. If you have to tell people you are, you aren't.

Margaret Thatcher

A leader does not set out to be a leader, but becomes one by the equality of his actions and the integrity of his intent.

General MacArthur

I could not tread these perilous paths in safety if I did not keep a saving sense of humour.

Horatio Nelson

Any American who is prepared to run for president should automatically, by definition, be disqualified from ever doing so.

Gore Vidal

Before we acquire great power we must acquire wisdom to use it well.

Ralph Waldo Emerson

A good leader stands at the front of his army, though it might cost him his life. A bad leader hides at the back, and thus loses all.

Great leaders are not defined by the absence of weakness, but rather by the presence of clear strengths.

John Zenger

A leader is a dealer in hope.

Napoleon Bonaparte

A true king is neither husband nor father; he considers his throne and nothing else.

Pierre Corneille

Every cook has to learn how to govern the state.

Vladimir Lenin

A good leader says, 'We could have played better.' A great leader says, 'I could have played better', even if he has the best game of his life.

Leaders need to be visionary yet practical, teachers yet learners, and believers yet open-minded. ***Med Yones***

He is not strong and powerful who throweth people down; but he is strong who witholdeth himself from anger.

Muhammad

Leaders think and talk about the solutions. Followers think and talk about the problems.

Brian Tracy

**Be humble for you are made of earth.
Be noble for you are made of stars.**

Be strong, but not rude; be kind, but not weak; be bold, but not a bully; be thoughtful, but not lazy; be humble, but not timid; be proud, but not arrogant; have humour, but without folly. *Jim Rohn*

A person who deserves my loyalty receives it.
Joyce Maynard

Leaders establish trust with candour, transparency and credit. *John Welsh*

Never forget that the most powerful force on earth is love.

Nelson Rockefeller

Energy, invincible determination with the right motive, are the levers that move the world.

Noah Porter

Every human being is intended to have a character of his own; to be what no others are, and to do what no other can do.

William Henry Channing

A leader is one who knows where he wants to go, and gets up, and goes.

John Erskine

Kings detest wrongdoing, for a throne is established through righteousness.

The Bible, Proverbs 16:12

He who has never learned to obey cannot be a good commander.

Aristotle

Be gentle and you can be bold; be frugal and you can be liberal; avoid putting yourself before others and you can become a leader among men. *Lao Tzu*

Immense power is acquired by assuring yourself in your secret reveries that you were born to control affairs.

Andrew Carnegie

Discontent is the source of all trouble, but also of all progress, in individuals and nations.

Berthold Auerbach

Make the best use of what is in your power, and take the rest as it happens.

Epictetus

Ability is of little account without opportunity.

Napoleon Bonaparte

Impatience never commanded success.

Edwin H. Chapin

Leadership and learning are indispensable to each other.

John F. Kennedy

Be one of a kind.

Big people monopolize
the listening, small people
monopolize the talking.

David Schwartz

No great man ever
complains of want
of opportunities.

Ralph Waldo Emerson

Not all readers are leaders, but all leaders are readers.

Harry S. Truman

A general is just as good or just as bad as the troops under his command make him.

General MacArthur

Become the kind of leader that people would follow voluntarily, even if you had no title or position. ***Brian Tracy***

Kings take pleasure in honest lips; they value a man who speaks the truth. *The Bible, Proverbs 16:13*

Much tongue and much judgment seldom go together.
Roger L'Estrange

Admit your weaknesses, but show your strengths.

In any position of leadership, you have to be obsessed.

Pat Riley

Never listen and you're stubborn. Always listen and you're weak.

A true teacher is one who, keeping the past alive, is also able to understand the present.

Confucius

I am endlessly fascinated that playing football is considered a training ground for leadership, but raising children isn't.

Dee Dee Myers

Everyone has the power to excel.

No man can stand on top because he is put there.

H.H. Vreeland

Reputation is for time; character is for eternity.

J.B. Gough

Education is the mother of leadership.

Wendell L. Willkie

It is of little traits that the greatest human character is composed.

William Winter

In my country we go to prison first and then become president.

Nelson Mandela

Our powers of judgment are more completely exposed by being overpraised than by being unjustly underestimated.

Friedrich Nietzsche

The best leaders understand that the 'good' is the enemy of the 'best'.

Patrick Driessen

A man can't ride your back unless it's bent.

Martin Luther King, Jr.

Correct yourself before correcting others.

Such as we are made of, such we be.

William Shakespeare

I was not a messiah, but an ordinary man who had become a leader because of extraordinary circumstances.

Nelson Mandela

Persistence and determination alone are omnipotent.

Calvin Coolidge

Destiny is not a matter of chance but a matter of choice. It is not a thing to be waited for, it is a thing to be achieved.

William Jennings Bryan

If you can, help others; if you cannot, at least do not harm them.

Dalai Lama

Be part of the solution, not part of the problem.

Respect yourself if you would have others respect you.

Baltasar Gracián

Some heroes' capes are invisible.

Circumstances are beyond human control, but our conduct is in our own power.

Benjamin Disraeli

Next to power without honour, the most dangerous thing in the world is power without humour.

Eric Sevareid

Disagree without being disagreeable.

The essential thing is not knowledge, but character.

Joseph LeConte

Yes, know thyself: in great concerns or small.
Be this thy care, for this, my friend, is all.

Juvenal

Leaders relentlessly upgrade their team using every encounter as an opportunity to evaluate, coach and build self-confidence. ***John Welsh***

Self-reverence, self-knowledge, self-control; these three alone lead one to sovereign power.

Alfred Lord Tennyson

The greater a man is in power above others, the more he ought to excel them in virtue. None ought to govern who is not better than the governed.

Publilius Syrus

The humblest individual exerts some influence, either for good or evil, upon others.

Henry Ward Beecher

Fortune favours the brave.

Ancient Roman proverb

It is impossible to imagine anything which better becomes a ruler than mercy.

Seneca the Younger

Reason and judgment are the qualities of a leader.

Tacitus

People expect their leaders to be better human beings than those who chose them.

General Schwarzkopf

Power is given only to those who dare to lower themselves and pick it up.

Fyodor Dostoyevsky

By three methods we may learn wisdom: first, by reflection, which is noblest; second, by imitation, which is easiest; and third by experience, which is the bitterest.

Confucius

People ask the difference between a leader and a boss. The leader leads, the boss drives.

Theodore Roosevelt

You must be the change you wish to see in the world.

Mahatma Gandhi

Great souls have wills, feeble ones have only wishes. *Chinese proverb*

To manage men one ought to have a sharp mind in a velvet sheath.

George Eliot

By learning you will teach; by teaching you will understand.

Real leaders are ordinary people with extraordinary determination.

Heroism is measured by the heart.

To govern mankind, one must not overrate them.

Lord Chesterfield

Whoever is new to power is always harsh.

Aeschylus

Men of genius are admired. Men of wealth are envied. Men of power are feared, but only men of character are trusted.

Arthur Friedman

Practise yourself in little things, and thence proceed to greater.

Epictetus

A lot of people have gone farther than they thought they could because someone else thought they could.

Zig Ziglar

The ability to keep a cool head in an emergency, maintain poise in the midst of excitement, and to refuse to be stampeded are true marks of leadership.

Anybody can become angry – that is easy, but to be angry with the right person and to the right degree and at the right time and for the right purpose, and in the right way – that is not within everybody's power and is not easy.

Aristotle

Love and faithfulness keep a king safe; through love his throne is made secure.

The Bible, Proverbs 20:28

Great leaders are great simplifiers.

General Colin Powell

Those who risk nothing risk being nothing.

Leonid S. Sukhorukov

To be a leader you have to be a servant first.

Pride defeats its own end, by bringing the man who seeks esteem and reverence into contempt.

Henry Bolingbroke

A true leader stoops to lift his comrades.

Throughout history, great leaders have known the power of humour.

Allen Klein

Talk by the inch, listen by the yard.

The better a man is, the more he is inspired to glory. *Cicero*

When everyone is thinking the same, no one is thinking.

John Wooden

Society is a troop of thinkers and the best heads among them take the best places.

Ralph Waldo Emerson

The man of life upright has a guiltless heart, free from all dishonest deeds or thought of vanity. ***Thomas Carlyle***

Whatever you are, be a good one.

Abraham Lincoln

When the student is ready, the teacher will appear.

You can't lead an army from the rear.

Nurture your mind with great thoughts. To believe in the heroic makes heroes.

Benjamin Disraeli

The way to have power is to take it.

Boss Tweed

There are no limitations but those we impose on ourselves.

Wisdom, compassion, and courage are the three universally recognized moral qualities of men. *Confucius*

If you choose not to follow, aren't you just following those who chose to lead?

The more tranquil a man becomes, the greater is his success, his influence, his power for good.

James Allen

A true leader does not know where he is going. He has faith that he will end up where he is supposed to be.

Rely on your own strength of body and soul. Take for your star self-reliance, faith, honesty and industry.

Noah Porter

The real leader has no need to lead – he is content to point the way.

Henry Miller

The supreme quality for leadership is unquestionably integrity. Without it, no real success is possible, no matter whether it is on a section gang, a football field, in an army, or in an office.

Dwight D. Eisenhower

The wisest have the most authority.

Plato

Where there is reverence there is fear, but there is not reverence everywhere that there is fear.

Socrates

You cannot become a leader through luck alone. If you did, what would you have to teach others?

You don't need a title to be a leader.

Victory attained by violence is tantamount to a defeat, for it is momentary.

Mahatma Gandhi

We cannot hold a torch to light another's path without brightening our own.

Ben Sweetland

Leaders aren't created in just one day.

You don't have to be a 'person of influence' to be influential.

Scott Adams

You don't lead by hitting people over the head.

Dwight D. Eisenhower

The most hateful human misfortune is for a wise man to have no influence.

Herodotus

Those who intend to wear the crown must be willing to bear the cross.

The superior man acquaints himself with many sayings of antiquity and many deeds of the past, in order to strengthen his character thereby.
John Milton

Try to be different and you will end up being the same. Try to be yourself and you will stand out.

No one ever teaches
well who wants to teach,
or governs well who
wants to govern. *Plato*

**The most dangerous leadership
myth is that leaders are born.**

Warren Bennis

Don't follow the road,
create your own path.

No man has any natural authority over his fellow men.

Jean-Jacques Rousseau

No man is good enough to govern another man without that other's consent. **Abraham Lincoln**

It is absurd that a man should rule others who cannot rule himself.

Latin proverb

Nature magically suits a man to his fortunes, by making them the fruit of his character.

Ralph Waldo Emerson

We must have the highest standards of morality, ethics and integrity if we are to continue to have influence.

Billy Graham

What you are must always displease you, if you would attain to that which you are not.

St Augustine

When in doubt, mumble; when in trouble, delegate; when in charge, ponder.

James H. Boren

Leaders probe and push with a curiosity that borders on scepticism, making sure their questions are answered with action.

John Welsh

The power is detested, and miserable the life, of him who wishes to be feared rather than to be loved.

Cornelius Nepos

Some are born great, some achieve greatness, and some have greatness thrust upon them.

William Shakespeare

Do the best job and remove all competition.

High expectations are the key to everything.

Sam Walton

The potential for greatness lives within each of us. *Wilma Rudolph*

It is a well-known fact that those people who must want to rule people are, *ipso facto*, those least suited to do it.

Douglas Adams

It is not in the nature of politics that the best men should be elected. The best men do not want to govern their fellow men.

George MacDonald

People buy into the leader before they buy into the vision.

John C. Maxwell

We make our fortunes, and we call them fate.

Benjamin Disraeli

At the end of the game, pawns and kings go back into the same box.

Life at the Top

How does life treat our leaders and how should they behave once power has been attained?

If you don't ask, you don't get.

It is difficult to violently suppress people in the long run.

Dalai Lama

Those who deny freedom to others deserve it not for themselves.

Abraham Lincoln

Work with your enemy to make him your partner.

To delight in war is a merit in the soldier, a dangerous quality in the captain and a positive crime in the statesman.

George Santayana

You will always get what you expect in people. If you set a reasonable standard and say no more or no less, you'll get it.

The measure of a man is what he does with power.

Plato

The only maxim of a free government ought to be to trust no man living with power to endanger the public liberty.

John Adams

The price of greatness is responsibility.
Sir Winston Churchill

You gain strength, courage and confidence by every experience in which you really stop to look fear in the face. You must do the thing you think you cannot do.

Eleanor Roosevelt

First rule of leadership: everything is your fault.

I had rather be first in a village than second at Rome.

Julius Caesar

I must follow the people. Am I not their leader?

Benjamin Disraeli

Never attribute to malice what is explained by incompetence.

Napoleon Bonaparte

The orchestra has the power, and every member of it knows instantaneously if you're just beating time.

Itzhak Perlman

One of the best ways to persuade others is with your ears.

Dean Rusk

When you've robbed a man of everything, he's no longer in your power – he's free again.

Aleksandr Solzhenitsyn

If you command wisely, you'll be obeyed cheerfully.

Thomas Fuller

Watch the steps you take today. They may become footprints for another.

Give credit where credit is due.

In the practice of tolerance, one's enemy is the best teacher.

Dalai Lama

I have to have a dictatorship. I can't be told that I'm wrong.

Trevor Nunn

If you can't change the people in the world, change the world.

In motivating people, you've got to engage their minds and their hearts.

Rupert Murdoch

If you've got them by the balls, their hearts and minds will follow.

John Wayne

Warn a divisive person once, and then warn them a second time. After that, have nothing to do with them.

The Bible, Titus 3:10

I have to get the most energy out of a man and have discovered it cannot be done if he hates another man.

Knute Rockne

If you think you are leading and turn around to see no one following, then you are just taking a walk.

Benjamin Hooks

It is a mistake to look too far ahead. Only one link of the chain of destiny can be handled at a time.

Sir Winston Churchill

What it lies in our power to do, it lies in our power not to do.

Aristotle

Look defeat in the eye,
but don't swallow it.

The man whose authority is recent is always stern.

Aeschylus

What we do in life echoes in eternity.

Maximus Decimus Meridius

Regard your soldiers as your children, and they will follow you into the deepest valleys; look on them as your own beloved sons, and they will stand by you even unto death.

Sun Tzu

Ruling others has one advantage: you can do more good than anyone else.

Baltasar Gracián

Pay heed to ideas that challenge your own; then you can reject them with confidence.

Under the influence of fear, which always leads men to take a pessimistic view of things, they magnified their enemies' resources, and minimized their own.

Titus Livius

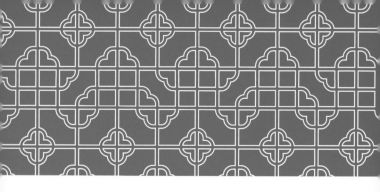

Plans fail for lack of counsel, but with many advisers they succeed.

You've got to give loyalty down, if you want loyalty up.

Donald T. Regan

Never be led by
your problems.

There will always be someone
who misunderstands.

**Today is the most
important day in
a leader's life.**

We must not contradict,
but instruct him that
contradicts us;
for a madman is not
cured by another
running mad also.

An Wang

When power corrupts, poetry cleanses.

John F. Kennedy

Nobody is as powerful as we make them out to be.

Alice Walker

To climb steep hills requires a slow pace at first.

William Shakespeare

When elephants fight, it is the grass that suffers.

African proverb

The printing press is the greatest weapon in the armoury of the modern commander.

T. E. Lawrence

When a king sits on his throne to judge, he winnows out all evil with his eyes.

The Bible, Proverbs 20:8

Loyalty and devotion lead to bravery. Bravery leads to the spirit of self-sacrifice. The spirit of self-sacrifice creates trust in the power of love.

Morihei Ueshiba

Powerful people cannot afford to educate the people that they oppress, because once you are truly educated, you will not ask for power. You will take it.

John Henrik Clarke

There is nothing noble about being superior to some other man. The true nobility is in being superior to your previous self.

You can't use up creativity. The more you use, the more you have.
Maya Angelou

When in doubt, pause.

Whole-hearted effort is the pathway to success.

When a leader assumes, danger looms.

Bert Jones

You have not converted a man because you have silenced him.

John Morley

Lead with a loving mind and an intelligent heart.

Surround yourself with positive people.

Queen Latifah

You can fool all the people some of the time, and some of the people all the time, but you cannot fool all the people all the time.

Abraham Lincoln

Whatever you want to teach, be brief.

Horace

You don't have to explain victory and you can't explain defeat.

Darrell Royal

Create space for rivals
to prove to themselves
that you are still the
worthy king.

When advising others, remember that the same advice applies to you.

The inevitable must be accepted and turned to advantage.

Napoleon Bonaparte

There is a difference between getting the job done and getting the job done right.

Dwight C. Gibson, Jr.

The prudent man may direct a state, but it is the enthusiast who regenerates it.

Robert Bulwer-Lytton

Power is dangerous without humility.

Richard J. Daley

Silence is the ultimate weapon of power. *Charles de Gaulle*

The less people speak of their greatness, the more we think of it.

Francis Bacon

There go the people. I must follow them for I am their leader.

Alexandre Ledru-Rollin

Power tends to corrupt, and absolute power tends to corrupt absolutely.

Lord Acton

Always do what you're afraid to do.
Ralph Waldo Emerson

Leadership has never been
about popularity.
Marco Rubio

Love first, lead second.

It is unwise to be too sure of one's own wisdom. It is healthy to be reminded that the strongest might weaken and the wisest might err.

Mahatma Gandhi

Make decisions you can stand by, and stand by your decisions.

Justice and power must be brought together, so that whatever is just may be powerful, and whatever is powerful may be just.

Blaise Pascal

Leaders must be close enough to relate to others, but far enough ahead to motivate them.

John C. Maxwell

Be courteous to all, but intimate with few, and let those few be well tried before you give them your confidence.

George Washington

Be sure you put your feet in the right place, then stand firm.

Abraham Lincoln

Amuse as well as instruct.
Alfred E. Smith

Divide the fire and you will soon put it out.

Leave no stone unturned.

A wise man adapts himself to circumstances as water shapes itself to the vessel that contains it.

Chinese proverb

All compromise is based on give and take, but there can be no give and take on fundamentals.

Mahatma Gandhi

One must change one's tactics every ten years if one wishes to maintain superiority.

Napoleon Bonaparte

Other people can stop you temporarily. You're the only one who can do it permanently.

Zig Ziglar

Never let success go to your head, nor failure go to your heart.

Never try to teach a pig to sing.
It wastes your time and annoys the pig.

Be a yardstick
of quality.

Steve Jobs

Be known for pleasing others, especially if you govern them.

Baltasar Gracián

Be loyal to those who supported you on the way up.

Nothing will ever be attempted if all possible objections must first be overcome.

Samuel Johnson

The higher our position the more modestly we should behave.

Cicero

Courageous people do not fear forgiving, for the sake of peace.

Nelson Mandela

Forgiveness is not an occasional attitude, it's a way of life.

Martin Luther King, Jr.

Do what you feel in your heart to be right – for you'll be criticized anyway.

Eleanor Roosevelt

It is better to offer no excuse than a bad one.

George Washington

No captain can do very wrong if he places his ship alongside that of the enemy.

Horatio Nelson

One does not sell the earth upon which the people walk.

Chief Crazy Horse

A ruler should be slow to punish and swift to reward.

Ovid

Blessed is the leader who seeks the best for those he serves.

Desperate affairs require desperate measures.

Horatio Nelson

It does not matter how slowly you go so long as you do not stop.

Confucius

Never give an order that can't be obeyed.

General MacArthur

Leave your mark where others can only dream of going.

Power and position often make a man trifle with the truth.

George A. Smith

Take the front line when there is danger. Put others in front when you celebrate victory.

Nelson Mandela

Do not take advantage of your position to intimidate others.

Honest disagreement is often a good sign of progress.

Mahatma Gandhi

If the director is quiet,
the set is quiet.

Eva Marie Saint

**A good compromise,
a good piece of
legislation, is like a
good sentence; or a
good piece of music.
Everybody can
recognize it.**

Barack Obama

No general can fight his battles alone. He must depend upon his lieutenants, and his success depends upon his ability to select the right man for the right place.

Philip Danforth Armour

Determination and willpower can only be achieved when you proceed without hesitation or doubt.

I cannot give you the formula for success, but I can give you the formula for failure – which is: Try to please everybody.

Herbert Bayard Swope

Do not wait for ideal circumstances, nor for the best opportunities; they will never come.

Janet Erskine Stuart

Lenience will operate with greater force, in some instances, than rigour.

George Washington

First gain the victory and then make the best use of it you can.

Horatio Nelson

Good enough never is.

Do the right thing. It will gratify some people and astonish the rest.

Mark Twain

How can anyone govern a nation that has two hundred and forty-six different kinds of cheese?

Charles de Gaulle

If you are going to do anything, you must expect criticism.

Bruce Barton

If you can make a man laugh, you can make him think and make him like and believe you.

Alfred E. Smith

Take time to deliberate,
but when the time for
action has arrived,
stop thinking and go in.

Napoleon Bonaparte

The deterioration of every government begins with the decay of the principles on which it was founded.

Montesquieu

Fresh ideas grow from the resting bed.

I believe in benevolent dictatorship, provided I am the dictator.

Richard Branson

If a ruler listens to lies, all his officials become wicked.

The attempt to combine wisdom and power has only rarely been successful and then only for a short while.

Albert Einstein

The conductor's stand is not a continent of power, but an island of solitude.

Riccardo Muti

If what you're doing isn't moving you towards your goals, then it's moving you away from your goals.

Avinash Wandre

It takes tremendous discipline to control the power you have over other people's lives.

Clint Eastwood

Don't find fault, find a remedy.

Henry Ford

Give the labourer his wage
before his perspiration be dry.

Muhammad

It's the moment when you think no one's there that you are in the spotlight.

Take risks. Make mistakes.

The light of discovery never goes out.

Good decisions come from experience, and experience comes from bad decisions.

It is better to have more lightning in the hands than thunder in the mouth.

Chief Joseph

Words of Inspiration

Great leaders are remembered for their fine words – but what is the secret to speaking with authority?

A really great man is known by three signs – generosity in the design, humanity in the execution, moderation in success.

Otto von Bismarck

Always aim at complete harmony of thought and word and deed.

Mahatma Gandhi

Deliver your words not by number but by weight. *Proverb*

Friends, Romans, countrymen, lend me your ears.

William Shakespeare

Be sincere, be brief; be seated.

Franklin D. Roosevelt

Be silent, or say something better than silence.

Pythagoras

Earn your leadership every day.

Michael Jordan

Good, the more communicated, more abundant grows.

John Milton

Better than a thousand hollow words, is one word that brings peace.

Buddha

A speech is like a love affair. Any fool can start one, but to end it requires considerable skill. *Lord Mancroft*

A word of encouragement during a failure is worth more than an hour of praise after success.

Do you wish people to think well of you? Don't speak well of yourself.

Blaise Pascal

He who speaks without modesty will find it difficult to make his words good.

Confucius

I hope our wisdom will grow with our power and teach us that the less we use our power the greater it will be.

Thomas Jefferson

Direction, not intention, determines destination.

Andy Stanley

Industry is the parent of success.

Once you get people laughing, they're listening.

Herbert Gardner

If I have seen further it is by standing on the shoulders of giants.

Isaac Newton

Proper words in proper places make the true definition of a style.

Jonathan Swift

If you have an important point to make, don't try to be subtle or clever. Use the pile driver. Hit the point once. Then come back and hit it again. Then hit it a third time; a tremendous whack. *Sir Winston Churchill*

Kindness is in our power, even when fondness is not.

Samuel Johnson

A good leader is not the one who speaks the loudest but the one who speaks the most sense.

Our lives begin to end the day we become silent about things that matter.
Martin Luther King, Jr.

Every time you have to speak, you are auditioning for leadership.

James C. Humes

Speak as the populace but think as the learned.

Sir Edward Coke

Thought is the seed of action.

Ralph Waldo Emerson

If evil be said of thee, and if it be true, correct thyself; if it be a lie, laugh at it.

Epictetus

If you can't write your message in a sentence, you can't say it in an hour.

Dianna Booher

Be kind whenever possible. It is always possible.

Dalai Lama

I have nothing to offer but blood, toil, tears, and sweat.

Sir Winston Churchill

Speeches should be short.

Fidel Castro

Eloquence is the power to translate a truth into language perfectly intelligible to the person to whom you speak.

Ralph Waldo Emerson

I do not desire to live to distrust my faithful and loving people. Let tyrants fear.

Queen Elizabeth I

If Aristotle were alive today he'd have a talk show.

Timothy Leary

Only the prepared speaker deserves to be confident.

Dale Carnegie

You are here to enrich the world, and you impoverish yourself if you forget the errand.

Woodrow Wilson

Find out what's keeping them up nights and offer hope. Your theme must be an answer to their fears.

Gerald C. Meyers

Nothing is so unbelievable that oratory cannot make it acceptable.

Cicero

Education is the most powerful weapon which you can use to change the world.

Nelson Mandela

Get all your players playing for the name on the front of the jersey, not the one on the back.

A good leader can engage in a debate frankly and thoroughly, knowing that at the end he and the other side must be closer, and thus emerge stronger.

Nelson Mandela

A child miseducated is a child lost.

John F. Kennedy

Know the facts before you give an opinion.

Each time a man stands up for an ideal, or acts to improve the lot of others, or strikes out against injustice, he sends forth a tiny ripple of hope, and crossing each other from a million different centres of energy and daring, those ripples build a current that can sweep down the mightiest walls of oppression and resistance.

Robert F. Kennedy

Don't walk behind me; I may not lead.
Don't walk in front of me; I may not follow.
Just walk beside me and be my friend.

Albert Camus

Govern a great nation as you would
cook a small fish. Do not overdo it.

Lao Tzu

Collect as precious pearls the words of the wise and virtuous.

Abd-al-Kadir

Am I not destroying my enemies when I make friends of them?

Abraham Lincoln

I came, I saw, I conquered.

Julius Caesar

An eye for an eye only ends up making the whole world blind.

Mahatma Gandhi

Strive always to excel in virtue and truth.
Muhammad

They talk most who
have the least to say.
Matthew Prior

It should be your care, therefore, and mine, to elevate the minds of our children and exalt their courage; to accelerate and animate their industry and activity; to excite in them an habitual contempt of meanness, abhorrence of injustice and inhumanity, and an ambition to excel in every capacity, faculty, and virtue. *John Adams*

Talk does not cook rice.

Chinese proverb

Do not follow where the path may lead. Go instead where there is no path and leave a trail.

Harold R. McAlindon

Let us put our minds together and see what life we can make for our children.

Chief Sitting Bull

Exert your talents, and distinguish yourself, and don't think of retiring from the world, until the world will be sorry that you retire.

Samuel Johnson

If you talk to a man in a language he understands, that goes to his head. If you talk to him in his language, that goes to his heart.

Nelson Mandela

The object of oratory alone is not truth, but persuasion.

Thomas Babington Macaulay

Fourscore and seven years ago our fathers brought forth on this continent, a new nation, conceived in Liberty, and dedicated to the proposition that all men are created equal.

Abraham Lincoln

If you want others to be happy, practise compassion. If you want to be happy, practise compassion.

Dalai Lama

Don't let anyone speak for you, and don't rely on others to fight for you. *Michelle Obama*

Men govern nothing with more difficulty than their tongues.

Baruch Spinoza

The wise ones fashioned speech with their thought, sifting it as grain is sifted through a sieve. *Buddha*

When I'm getting ready to persuade a man I spend one third of the time thinking about myself, what I'm going to say, and two thirds of the time thinking about him and what he is going to say.

Abraham Lincoln

Liberty has never come from Government. Liberty has always come from the subjects of it. The history of liberty is a history of limitations of governmental power, not the increase of it.

Woodrow Wilson

Start by doing what's necessary, then do what's possible, and suddenly you are doing the impossible.

St Francis of Assisi

I know I have but the body of a weak and feeble woman; but I have the heart and stomach of a king, and of a king of England too, and think foul scorn that Parma or Spain, or any prince of Europe, should dare to invade the borders of my realm.

Queen Elizabeth I

The manager accepts the status quo; the leader challenges it.
Warren Bennis

Many can argue – not many converse.

Amos Bronson Alcott

To win without risk is to triumph without glory. *Pierre Corneille*

We must learn to live together as brothers or perish together as fools.

Martin Luther King, Jr.

Loyalty means nothing unless it has at its heart the absolute principle of self-sacrifice.

Woodrow Wilson

**Say not always what you know,
but always know what you say.**

Claudius

Orators are most vehement when their cause is weak.

Cicero

**The journey of a thousand miles
begins with a single step.**

Lao Tzu

What you cannot enforce,
do not command.

Sophocles

**In the end, it's not the years
in your life that count.
It's the life in your years.**

Abraham Lincoln

Speak when you are angry
and you will make the best
speech you will ever regret.

Ambrose Bierce

The people only understand what they can feel; the only orators that can affect them are those who move them.

Alphonse de Lamartine

Today's public figures can no longer write their own speeches or books, and there is some evidence that they can't read them either.

Gore Vidal

We are the ones we've been waiting for. We are the change that we seek.

Barack Obama

Lincoln was not a great man because he was born in a log cabin, but because he got out of it.

James Truslow Adams

In
Action
and
Adversity

**How important are our actions
and what can we learn from the
way we respond to set-backs?**

A man is great by deeds, not by birth.

Chanakya

He who has great power should use it lightly.

Seneca the Younger

Leadership is action, not position.

Donald H. McGannon

A superior man is modest in his speech, but exceeds in his actions.

Confucius

It is part of a good man to do great and noble deeds, though he risk everything. *Plutarch*

Act, and God will act.

Joan of Arc

**Heaven never helps the man
who will not help himself.**

Sophocles

I hear and I forget.
I see and I remember.
I do and I understand.

Confucius

**As your deed is,
so is your destiny.**

Brihadaranyaka Upanishad IV 4.5

Leadership is practised not so much in words as in attitude and in actions.

Harold S. Geneen

Let's change it 'cause no one else will.

If you want a quality, act as if you already had it.

William James

Lead me, follow me, or get out of my way.

General Patton

Leaders do what it takes.

Pellom McDaniels III

As one star another far exceeds, so souls in heaven are placed by their deeds.

Robert Greene

If you would not be forgotten, as soon as you are dead and rotten, either write things worth reading, or do things worth the writing.

Benjamin Franklin

Great minds have purpose. Others have wishes.

People know you for what you've done, not for what you plan to do.

The man who removes a mountain begins by carrying away small stones.

Confucius

Action expresses priorities.

Mahatma Gandhi

Neither soldiers nor money can defend a king but only friends won by good deeds, merit and honesty.

Sallust

Speak out in acts; the time for words has passed, and only deeds will suffice.

Alfred North Whitehead

Don't count the days of the week; make every day count.

Men make history and not the other way around. In periods where there is no leadership, society stands still.

Harry S. Truman

Our acts make or mar us. We are the children of our own deeds.

Victor Hugo

It takes many good deeds to build a good reputation, and only one bad one to lose it.

Benjamin Franklin

Men do less than they ought, unless they do all they can.

Thomas Carlyle

Other famous men, those of much talk and few deeds, soon evaporate. Action is the dignity of greatness.

José Martí

Good deeds and good intentions
are as far apart as Heaven and Hell.

Ben Harper

Not a day passes over the earth, but men and women of no note do great deeds, speak great words and suffer noble sorrows.

Charles Reade

Nothing so conclusively proves a man's ability to lead others as what he does from day to day to lead himself.

Thomas J. Watson, Sr.

Actions speak louder than words.

Proverb

Losers make excuses, winners make changes.

Not the cry, but the flight of a wild duck, leads the flock to fly and follow.

Chinese proverb

**Nothing strengthens
authority so much as silence.**

Leonardo da Vinci

Do not wait to strike till
the iron is hot; but make
it hot by striking.

W.B. Yeats

**People don't listen
to you speak, they
watch your feet.**

The doer moves; the critic stands still, and is passed by.

Bruce Barton

Don't wait for extraordinary opportunities. Seize common occasions and make them great.

Orison Swett Marden

If your actions inspire others to dream more, learn more, do more and become more, you are a leader.

John Quincy Adams

What you do has far greater impact than what you say.

Stephen Covey

You cannot dream yourself into a character; you must hammer and forge yourself one.

Henry David Thoreau

The way to gain a good reputation is to endeavour to be what you desire to appear.

Socrates

Those who aim at great deeds must also suffer greatly.

Plutarch

To reach a port, we must sail. Sail, not tie at anchor. Sail, not drift.

Franklin Roosevelt

A leader has the ability to recognize a problem before it becomes an emergency.
Arnold Glasow

An oak is not felled at one blow.

Spanish proverb

It is better to die standing than to live forever on your knees.

Emiliano Zapata

The nation will find it very hard to look up to the leaders who are keeping their ears to the ground.

Sir Winston Churchill

You don't lead by pointing and telling people some place to go. You lead by going to that place and making a case.

Ken Kesey

Anyone can hold the helm when the sea is calm.

Publilius Syrus

Don't necessarily avoid sharp edges. Occasionally they are necessary to leadership.

Donald Rumsfeld

Our greatest glory consists not in never falling, but in rising every time we fall.

Oliver Goldsmith

Adversity is wont to reveal genius, prosperity to hide it.

Horace

He who fears being conquered is sure of defeat.

Napoleon Bonaparte

Misfortunes disclose the skill of a general; success conceals his weakness.

Horace

Successful leaders face defeat with a heart of enduring optimism.

Reed Markham

Look for the opportunity in every difficulty, not the difficulty in every opportunity.

The most audacious actions for life, liberty and justice are taken by the most innovative person, not afraid to live life instead of dreaming it.

After climbing a great hill, one only finds that there are many more hills to climb.

Nelson Mandela

Great spirits have always encountered violent opposition from mediocre minds.

Albert Einstein

Accept the challenges so that you may feel the exhilaration of victory.

General Patton

Obstacles were meant for the weak, because the strong will always overcome them.

Failure is the fertilizer of success.
Denis Waitley

Little minds are tamed and subdued by misfortunes; but great minds rise above them.
Washington Irving

The gem cannot be polished without friction, nor man be perfected without trials. *Chinese proverb*

There is no excellence uncoupled with difficulties.

Ovid

Wherever we look upon this earth, the opportunities take shape within the problems.

Nelson Rockefeller

You can only become a true and successful leader once you have really lost a couple of times.

Patrick Driessen

Go back a little to leap further.

John Clarke

The greatest men sometimes overshoot themselves, but then their very mistakes are so many lessons of instruction.

Tom Browne

The situation brings out the leader in you.

The ultimate measure of man is not where he stands in moments of comfort and convenience, but where he stands at times of challenge and controversy.

Martin Luther King, Jr.

Show me a leader who has made no mistakes and I will show you a leader who has made no progress.

Reed Markham

They fail, and they alone,
who have not striven.

Thomas Bailey Aldrich

When it is dark enough, you can see the stars.

Our task now is not to fix blame for the past, but to fix the course for the future.

John F. Kennedy

Storms make oaks take root.

Proverb

The block of granite which was an obstacle in the pathway of the weak became a stepping-stone in the pathway of the strong.

Thomas Carlyle

Vision and Conviction

A leader needs a cause, a belief, and the courage to see it through against all opposition.

Good things happen to those who hustle.

Anaïs Nin

A man who wants to lead the orchestra must turn his back on the crowd.

Max Lucado

Don't be afraid to give up the good to go for the great.

John D. Rockefeller

In matters of style, swim with the current; in matters of principle, stand like a rock.

Thomas Jefferson

A bold onset is half the battle.

Giuseppe Garibaldi

Belief creates the actual fact.

William James

Confidence is contagious.

Vince Lombardi

A 'No' uttered from the deepest conviction is better than a 'Yes' merely uttered to please.

Mahatma Gandhi

Determine that the thing can and shall be done, and then we shall find the way.

Abraham Lincoln

A good plan violently executed now is better than a perfect plan executed next week.

General Patton

Be slow to form convictions, but once formed they must be defended against the heaviest odds.

Mahatma Gandhi

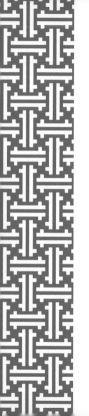

A leader takes people where they want to go. A great leader takes people where they ought to be. *Rosalynn Carter*

If you would convince others, seem open to conviction yourself.

Lord Chesterfield

Every noble work is at first impossible.

Thomas Carlyle

It is better to lose one enemy than gain a hundred friends.

Reed Harvey

Never say die.

Conviction never so excellent, is worthless until it converts itself into conduct.

Thomas Carlyle

Courage and conviction are powerful weapons against an enemy who depends only on fists or guns.

David Seabury

I cannot teach you violence, as I do not myself believe in it. I can only teach you not to bow your heads before anyone even at the cost of your life.

Mahatma Gandhi

You can't blow an uncertain trumpet.

A genuine leader is not a searcher for consensus but a moulder of consensus.

Martin Luther King, Jr.

Courage is the first of human qualities because it is the quality which guarantees all others.

Sir Winston Churchill

Keep progressing, hold firm and retain your passion.

Leaders have the courage to make unpopular decisions and gut calls.

John Welsh

Know when to cause anger and when to offer joy.

Let him who would be moved to convince others, be first moved to convince himself.

Thomas Carlyle

When I use my strength in the service of my vision it makes no difference whether or not I am afraid.

Audre Lorde

Doubt separates people.

Buddha

He who hesitates is lost.

Leadership does not always wear the harness of compromise.

Woodrow Wilson

Nothing can stop the man with the right mental attitude from achieving his goal; nothing on earth can help the man with the wrong mental attitude.

Thomas Jefferson

A true leader has the confidence to stand alone, the courage to make tough decisions, and the compassion to listen to the needs of others.

General MacArthur

Animals know when you are afraid; a coward knows when you are not.

David Seabury

Loyalty to petrified opinion never yet broke a chain or freed a human soul.

Mark Twain

Our doubts are traitors, and make us lose the good we oft might win, by fearing to attempt.

William Shakespeare

Conviction without experience makes for harshness.

Flannery O'Connor

Don't take too much advice – keep at the helm and steer your own ship.

Noah Porter

It always seems impossible until it's done.

Nelson Mandela

One cannot govern with 'buts'.

Charles de Gaulle

One person with a belief is equal to ninety-nine who have only interests.

John Stuart Mill

Any man or institution that tries to rob me of my dignity will lose.

Nelson Mandela

Difficulties vanish when faced boldly.

Isaac Asimov

Keep one step ahead.

Only one thing matters, one thing; to be able to dare!

Fyodor Dostoyevsky

Stick to your conviction, but be ready to abandon your assumptions.

Denis Waitley

278

Belief in oneself is one of
the most important bricks in
building any successful venture.
Lydia Child

Stay committed to
your decisions; but
stay flexible in your
approach.
Tony Robbins

The best lack all conviction, while the worst are full of passionate intensity. *W.B. Yeats*

There is nothing more dreadful than the habit of doubt.
Buddha

You have within you the strength, the patience and the passion to reach for the stars to change the world.

Harriet Tubman

Take calculated risks. That is quite different from being rash.

General Patton

They can because they think they can.
Virgil

Trust thyself: every heart vibrates to that iron string.
Ralph Waldo Emerson

The day a leader is not willing to tell his followers that they are wrong is the day he is no longer fit to lead them.

To sacrifice what you are and to live without belief, that is a fate more terrible than dying.

Joan of Arc

Who looks outside, dreams; who looks inside, awakes.

Carl Jung

They can conquer who believe they can.

Ralph Waldo Emerson

Two captains sink the ship.

A genuine leader is not a searcher for consensus but a molder of consensus.
Martin Luther King, Jr.

We only become what we are by the radical and deep-seated refusal of that which others have made of us.

Jean-Paul Sartre

You can buy a person's hands but you can't buy his heart. His heart is where his enthusiasm, his loyalty is.

Stephen Covey

Your vision will become clear only when you can look into your own heart.

Carl Jung

A good general not only sees the way to victory; he also knows when victory is impossible.

Polybius

Do we not all agree to call rapid thought and noble impulse by the name of inspiration?

George Eliot

Vision without action is merely a dream. Action without vision just passes the time. Vision with action can change the world.

Joel A. Barker

Ah, but a man's reach should exceed his grasp, or what's a heaven for?

Robert Browning

A leader has the vision and conviction that a dream can be achieved. He inspires the power and energy to get it done.

Ralph Nader

A leader is one who sees more than others see, who sees farther than others see, and who sees before others see.

Leroy Eimes

Vision is the art of seeing what is invisible to others.

Jonathan Swift

A great leader's courage to fulfil his vision comes from passion, not position.

John C. Maxwell

All great deeds
and all great
thoughts have
a ridiculous
beginning.

Albert Camus

**All the forces in the world are
not so powerful as an idea
whose time has come.**

Victor Hugo

A solitary fantasy can totally transform one million realities.

Maya Angelou

For want of a vision the people perish.

The Bible, Proverbs 29:18

The greatest leaders mobilize others by coalescing people around a shared vision.

Ken Blanchard

A very great vision is needed and the man who has it must follow it as the eagle seeks the deepest blue of the sky.

Chief Crazy Horse

Happy are those who dream dreams and are ready to pay the price to make them come true.

Leon J. Suenes

There is a boundary to men's passions when they act from feelings; but none when they are under the influence of imagination.

Edmund Burke

All men dream, but not equally.

T. E. Lawrence

Don't bury your thoughts, put your vision to reality.

Bob Marley

Dream big and dare to fail.

Norman Vaughan

Give to us clear vision that we may know where to stand and what to stand for – because unless we stand for something, we shall fall for anything.

Peter Marshall

If a man does not know to what port he is steering, no wind is favourable to him.

Seneca the Younger

If one advances confidently in the direction of his dreams and endeavours to live the life which he has imagined, he will meet with success unexpected in common hours.

Henry David Thoreau

If the highest aim of a captain were to preserve his ship, he would keep it in port forever.

Thomas Aquinas

Throughout the centuries there were men who took first steps, down new roads, armed with nothing but their own vision.

Ayn Rand

Dream no small dreams for they have no power to move the hearts of men.

Johann Wolfgang von Goethe

If you think in terms of a year, plant a seed; if in terms of ten years, plant trees; if in terms of a hundred years, teach the people.

Confucius

Dreams are today's answers to tomorrow's questions.

Edgar Cayce

Every great dream begins with a dreamer.

Harriet Tubman

I had rather have a plain, russet-coated Captain, that knows what he fights for, and loves what he knows, than that which you call a gentleman and is nothing else.

Oliver Cromwell

In order to carry a positive action we must develop here a positive vision.

Dalai Lama

Dreams are the seedlings of realities.

James Allen

Inspiration and genius – one and the same.

Victor Hugo

The very essence of leadership is that you have to have a vision.

Reverend Theodore Hesburgh

**If you have built castles in the air,
your work need not be lost;
that is where they should be.
Now put foundations under them.**

Henry David Thoreau

Cut through argument,
debate and doubt to offer
a solution everybody
can understand.

General Colin Powell

Dreams pass into the reality of action. From the action stems the dream again; and this interdependence produces the highest form of living.

Anaïs Nin

Experience is the child of thought, and thought is the child of action.

Benjamin Disraeli

Never doubt that a small group of thoughtful, concerned citizens can change the world. Indeed it is the only thing that ever has.

Margaret Mead

Great leaders are guided by uncommon sense.

Reed Markham

Man is a genius when he is dreaming.

Akira Kurosawa

Seeing is different to being told.

I have a dream.

Martin Luther King, Jr.

It is easier to go down a hill than up, but the view is from the top.
Arnold Bennett

Dreaming ties all mankind together.

Jack Kerouac

If you don't know where you are going, you'll end up someplace else.

Yogi Berra

In dreams begins responsibility.

W.B. Yeats

If the whole world decided today to follow you, then where would you lead them?

Victor Wooten

Look into the future and see things not as they are, but as they can become.

Thoughts are but dreams till their effects be tried.

William Shakespeare

Talk transmits a vision but action gives it credibility.

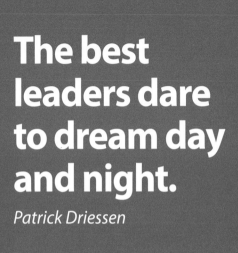

The best leaders dare to dream day and night.

Patrick Driessen

The power of imagination makes us infinite.

John Muir

Lots of things that couldn't be done have been done.

Charles Auston Bates

The world needs dreamers and the world needs doers. But above all, the world needs dreamers who do.

Sarah Ban Breathnach

All men of action are dreamers.

James Huneker

Leaders keep their eyes on the horizon, not just on the bottom line.

The spark of a tiny idea can ignite dynamic innovation.

Reed Markham

Society must set the artist free to follow his vision wherever it takes him.

John F. Kennedy

The responsibility of tolerance lies with those who have the wider vision.

George Eliot

Good business leaders create a vision, articulate the vision, passionately own the vision and relentlessly drive it to completion.

Jack Welch

Leaders make sure people not only see the vision, they live and breathe it.

John Welsh

Every man, as to character, is the creature of the age in which he lives. Very few are able to raise themselves above the ideas of their times.

Voltaire

The leader has to be practical and a realist yet must talk the language of the visionary and the idealist.

Eric Hoffer

Success is the child of audacity.
Benjamin Disraeli

The only way to predict the future is to have power to shape the future.

Eric Hoffer

There are those who look at things the way they are, and ask why? I dream of things that never were, and ask why not?

Robert F. Kennedy

The bravest are surely those
who have the clearest vision
of what is before them,
glory and danger alike,
and yet notwithstanding,
go out to meet it.

Thucydides

**The future belongs to
those who believe in the
beauty of their dreams.**

Eleanor Roosevelt

The Power to Empower

Successful leadership is not selfish. It's the strength you give to others that really makes the difference.

Education is not the filling of a pail, but the lighting of a fire.

W.B. Yeats

If people believe in themselves, it's amazing what they can accomplish.

Sam Walton

The growth and development of people is the highest calling of leadership.

Harvey Firestone

Be careful to leave your sons well instructed rather than rich, for the hopes of the instructed are better than the wealth of the ignorant.

Epictetus

If you want to build a ship, don't drum up people to collect wood and don't assign them tasks and work, but rather teach them to long for the endless immensity of the sea.

Antoine de Saint-Exupéry

As we look ahead into the next century, leaders will be those who empower others.

Bill Gates

Give a man a fish and you feed him for a day; teach a man to fish and you feed him for a lifetime.

Maimonides

The purpose of getting power is to be able to give it away.

Aneurin Bevan

All will govern in turn and will soon become accustomed to no one governing.

Vladimir Lenin

Always mistrust a subordinate who never finds fault with his superior.

John Churton Collins

Leaders must be
tough enough to fight,
tender enough to cry,
human enough to
make mistakes, humble
enough to admit them,
strong enough to absorb
the pain, and resilient
enough to bounce back
and keep on moving.

Jesse Jackson

One rule of action more important than all others consists in never doing anything that someone else can do for you.

Calvin Coolidge

**The purpose of life is not to win.
The purpose of life is to grow and share.**

Rabbi Harold Kushner

I am a firm believer in the people. If given the truth, they can be depended upon to meet any national crisis.

Abraham Lincoln

No man will make a great leader who wants to do it all himself, or to get all the credit for doing it.

Andrew Carnegie

The art of choosing men is not nearly so difficult as the art of enabling those one has chosen to attain their full worth.

Napoleon Bonaparte

Education makes a people easy to lead, but difficult to drive; easy to govern but impossible to enslave.

Henry Brougham

Technology is just a tool. In terms of getting the kids working together and motivating them, the teacher is the most important.

Bill Gates

When was ever honey made with one bee in a hive?

Thomas Hood

Outstanding leaders go out of their way to boost the self-esteem of their personnel.

Sam Walton

Those that know, do. Those that understand, teach.

Aristotle

When one treats people with benevolence, justice and righteousness, and reposes confidence in them, the army will be united in mind and all will be happy to serve their leaders.

Sun Tzu

A good leader inspires others with confidence. A great leader inspires them with confidence in themselves.

Reed Markham

Those who educate children well are more to be honoured than they who produce them; for these only gave them life, those the art of living well.

Aristotle

Unity is a precious diamond.

I am reminded how hollow the label of leadership sometimes is and how heroic followership can be.

Warren Bennis

Never forbid what you lack the power to prevent.

Napoleon Bonaparte

Tell me and I forget.
Teach me and I remember.
Involve me and I learn.
Benjamin Franklin

A competent leader can get efficient service from poor troops. An incapable leader can demoralize the best of troops. *General Pershing*

Too often we underestimate the power of a touch, a smile, a kind word, a listening ear, an honest compliment, or the smallest act of caring, all of which have the potential to turn a life around.

Leo Buscaglia

You can delegate authority, but you cannot delegate responsibility.

Byron Dorgan

I find that I sent wolves not shepherds to govern Ireland, for they have left me nothing but ashes and carcasses to reign over.

Queen Elizabeth I

Persuade people to do things and make them think it was their own idea.

Nelson Mandela

You can lead a horse to water but you cannot make it drink.

A good leader leads people to their inner strengths. A bad one drives them to their weaknesses.

Never tell people how to do things. Tell them what to do and they will surprise you with their ingenuity.

General Patton

When I give a minister an order, I leave it to him to find the means to carry it out.

Napoleon Bonaparte

A master can tell you what he expects of you. A teacher awakens your own expectations.

Patricia Neal

Teach people how to learn.
Peter Drucker

Teaching is the profession that creates all other professions.

A fresh pair of eyes can change the landscape of any problem.

Reed Markham

The teacher who is indeed wise does not bid you to enter the house of his wisdom but rather leads you to the threshold of your mind.

Khalil Gibran

Surround yourself with the best people you can find, delegate authority, and don't interfere as long as the policy you've decided upon is being carried out.

Ronald Reagan

The mediocre teacher tells.
The good teacher explains.
The superior teacher demonstrates.
The great teacher inspires.

William Arthur Ward

You must not fight too often with one enemy,
or you will teach him all your art of war.

Napoleon Bonaparte

Before you are a leader, success is all about growing yourself. When you become a leader, success is all about growing others.

Jack Welch

Behind an able man there are always other able men.

Put people in a position where they can excel.

Don Shula

The greatest sign of success for a teacher is to be able to say, 'The children are now working as if I did not exist.'

Maria Montessori

A good leader is one who gets up. A great leader is one who gives others the will to get up. The greatest of all is the one who inspires others to become great leaders.

Trần Văn Đôn

Force responsibility down and out. Find problem areas, add structure and delegate. The pressure is to do the reverse. Resist it.

Donald Rumsfeld

It marks a big step in a man's development when he comes to realize that others can be called in to help him do a better job than he can do alone.

Andrew Carnegie

Managers use power on their people. Leaders empower their people.

Recognize and value your staff.

Put two or three men in positions of conflicting authority. This will force them to work at loggerheads, allowing you to be the ultimate arbiter.

Franklin D. Roosevelt

The best executive is the one who has sense enough to pick good men to do what he wants done, and self-restraint enough to keep from meddling with them while they do it.

Theodore Roosevelt

You cannot teach
a man anything;
you can only
help him find it
within himself. *Galileo*

The final test of a leader is that he
leaves behind him, in other men, the
conviction and the will to carry on.

Walter Lippmann

The function of leadership is to produce more leaders, not more followers.

Ralph Nader

True leadership lies in guiding others to success.

Bill Owens

Ideal teachers are those who use themselves as bridges over which they invite their students to cross. Then, having facilitated their crossing, joyfully collapse, encouraging them to create bridges of their own.

Nikos Kazantzakis

No man is great enough or wise enough for any of us to surrender our destiny to. The only way in which anyone can lead us is to restore to us the belief in our own guidance.

Henry Miller

Leading by Example

If you want people to follow you, show them the way. People rally to a leader who takes his or her share of the burden.

Do as you would be done by.

Example is leadership.

Albert Schweitzer

Example is the school of mankind, and they will learn at no other.

Edmund Burke

People seldom improve when they have no other model but themselves to copy.

Oliver Goldsmith

The average motivate,
the great inspire.

Nothing is so contagious as example; and we never do any great good or evil which does not produce its like.

François de La Rochefoucauld

A good example is far better than a good precept.

Dwight L. Moody

A leader is someone who demonstrates what's possible.

Mark Yarnell

From my example learn to be just, and not to despise the gods.

Virgil

A moment's insight is sometimes worth a life's experience.

Oliver Wendell Holmes, Jr.

Experience is the teacher of all things.
Julius Caesar

He knows the water best who has waded through it.

Danish proverb

Let our lives be open books for all to study.

Mahatma Gandhi

Never ask your men to overcome an obstacle you can't overcome yourself.

Eric Fisher

The function of leadership is to produce more leaders, not more followers.

Ralph Nader

An ounce of practice is worth more than tons of preaching.

Mahatma Gandhi

Do not impose on others what you yourself do not desire.

Confucius

Govern thy life and thoughts as if the whole world were to see the one, and read the other.

Thomas Fuller

Good advice is something a man gives when he is too old to set a bad example.

François de La Rochefoucauld

**Sow an act and you reap a habit;
sow a habit and you reap a character;
sow a character and you reap a destiny.**

George Dana Boardman

The great art of commanding is to take a fair share of the work.

Noah Porter

Go before the people with your example, and be laborious in their affairs.

Confucius

Parents must lead by example. We are our children's first and most important role models.

Lee Haney

The most powerful moral influence is example.

Huston Smith

I don't know any other way to lead but by example.

Don Shula

If seniors can't lead by example, then they can't don the hat of mentor.

Man only learns in two ways: one by reading, the other by association with smarter people.
Will Rogers

So long as governments set the example of killing their enemies, private individuals will occasionally kill theirs.
Elbert Hubbard

Success in training the boy depends largely on the scoutmaster's own personal example.

Sir Robert Baden-Powell

The experience of others adds to our knowledge, but not to our wisdom; that is dearer bought.

Hosea Ballou

Leaders get into everyone's skin, exuding positive energy and optimism. *John Welsh*

Look at people for an example, but then make sure to do things your way.

Queen Latifah

Shameful deeds are taught by shameful deeds.

Sophocles

He that gives good advice builds with one hand; he that gives good counsel and example builds with both; but he that gives good admonition and bad example, builds with one hand and pulls down with the other.

Francis Bacon

I am an example of what is possible when girls from the very beginning of their lives are loved and nurtured by people around them. I was surrounded by extraordinary women in my life who taught me about quiet strength and dignity.

Michelle Obama

I motivate people, I hope, by example – and perhaps by excitement, by having productive ideas to make others feel involved.

Rupert Murdoch

If the government becomes the lawbreaker, it breeds contempt for law.

Louis Brandeis

It is good to learn what to avoid by studying the misfortunes of others.

Publilius Syrus

If you would know the road ahead, ask someone who has travelled it.

Chinese proverb

Remember that while you are tackling your responsibilities, you are also setting an example for others.

Set the example in everything you do, you never know who is watching.

The people follow the example of those above them.

Chinese proverb

A life lived with integrity, even if it lacks the trappings of fame and fortune, is a shining star in whose light others may follow in the years to come.

Denis Waitley

Example moves the world more than doctrine. The great exemplars are the poets of action, and it makes little difference whether they be forces for good or forces for evil.

Henry Miller

As a parent, I have a job as a role model to my children, and by extension, to other young people.
Kareem Abdul-Jabbar

I like being a role model because I know how much comfort my musical idols brought me.
Shirley Manson

You get treated in life the way you teach people to treat you.

Wayne Dyer

If I am walking with two other men, each of them will serve as my teacher. I will pick out the good points of the one and imitate them, and the bad points of the other and correct them in myself.

Confucius

Where ignorance is our master, there is no possibility of real peace.

Dalai Lama

Be your character what it will, it will be known, and nobody will take it upon your word.

Lord Chesterfield

Leaders inspire risk-taking and learning by setting the example.

John Welsh

Society is always taken by surprise at any new example of common sense.

Ralph Waldo Emerson

I never had a speech from my father . . . I just learned to be led by example. My father wasn't perfect.

Adam Sandler

Public misbehaviour by the famous is a powerful teaching tool.

Bill O'Reilly

You are already a role model – the question is, what kind?

Thinking good thoughts is not enough, doing good deeds is not enough, seeing others follow your good examples is enough.

Douglas Horton

You cannot teach what you do not know; you cannot lead where you do not go.

Spend enough time around success and failure, and you learn a reverence for possibility.

Dale Dauten

When you study great teachers ... you will learn much more from their caring and hard work than from their style.

William Glasser

I am come amongst you, as you see, at this time, not for my recreation and disport, but being resolved, in the midst and heat of the battle, to live and die amongst you all.

Queen Elizabeth I

If you must hold yourself up to your children as an object lesson, hold yourself up as a warning and not as an example.

George Bernard Shaw

1001 WAYS TO
LEADERSHIP

1001 Ways to Leadership is a valuable
collection of the wisdom and experience
of people who have succeeded – and
failed – at being in charge. Packed with
advice, from the profound to the playful,
and from the ancient past to the modern
day, this little treasury will be the perfect
companion as you set out on your journey
to lead from the front.

ISBN 978-1-78212-437-5

ARCTURUS